Mandalas
CIRCLES OF UNITY

UNPLUGGED

A NATURAL
SOURCE OF
HEALING

This EXPERIENCE belongs to:

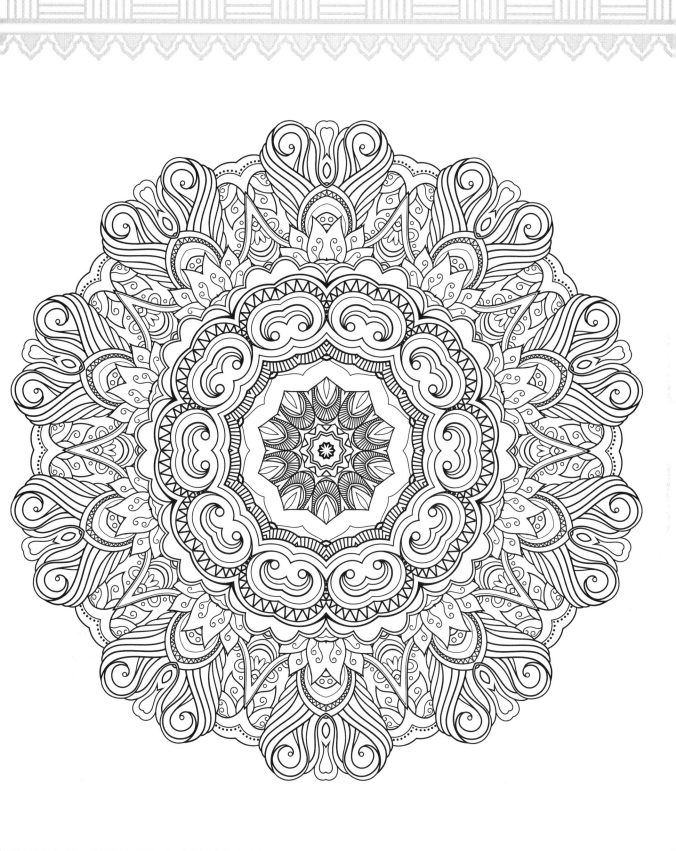

What does this picture make you wish for? Have you ever wished for that before? What do you believe helps wishes come true?

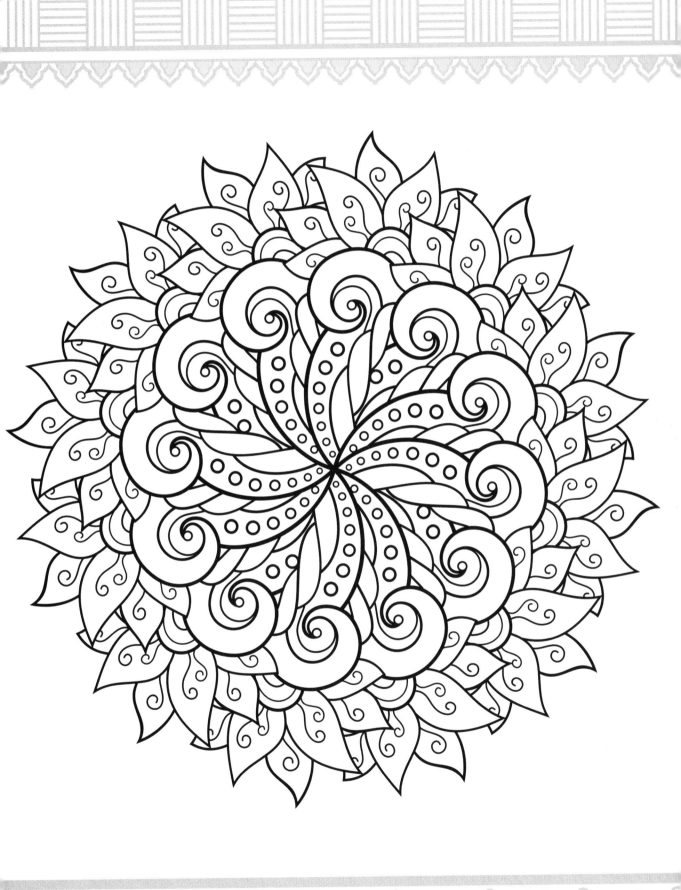

Do you know what kind of shapes and patterns calm you, and which create anxiety? Can you describe where you see these shapes and patterns in your life? How can you add more that calm you and remove those that heighten your anxiety?

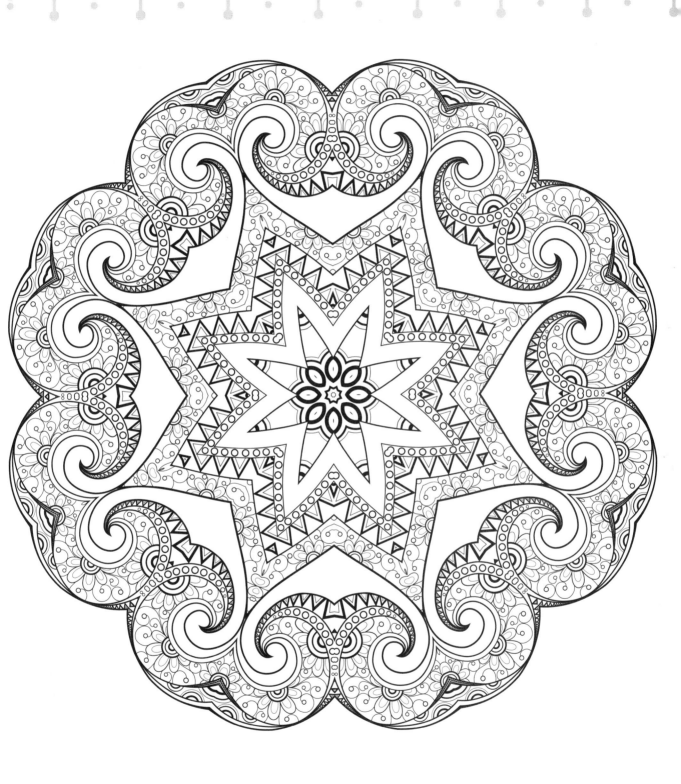

Unity is not the same thing as uniformity.
How is this true in your life?

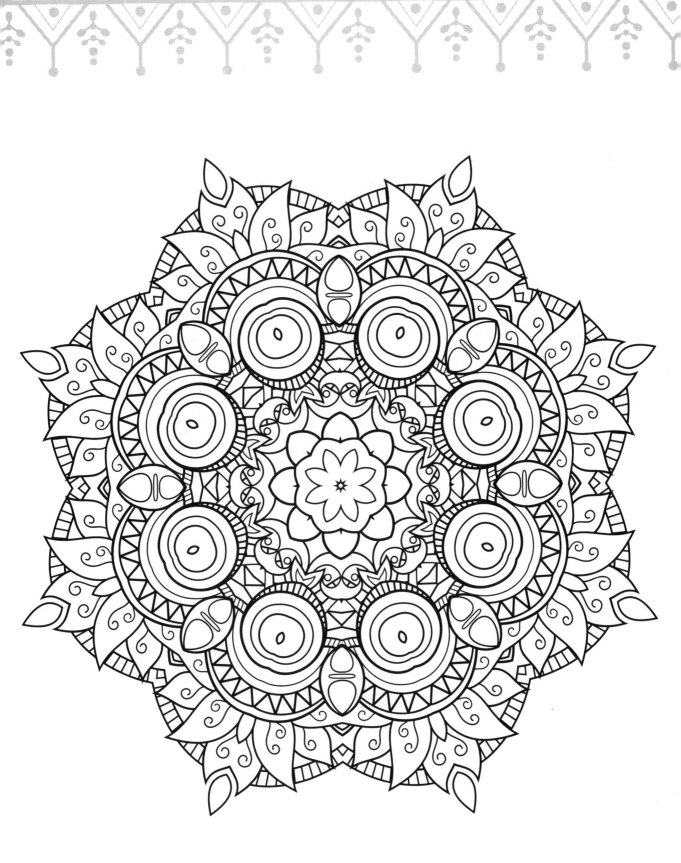

How do you think uniform patterns create a sense of calm in your life?

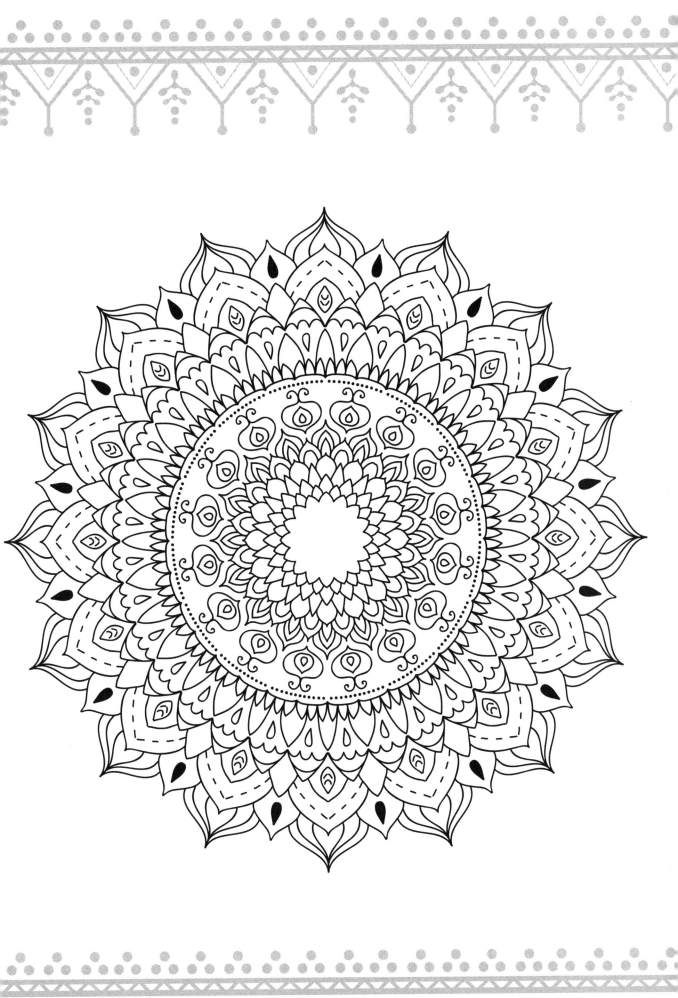

What about this picture brings out the best in you? Does the image look hopeful or kind? Lighthearted or spiritual?

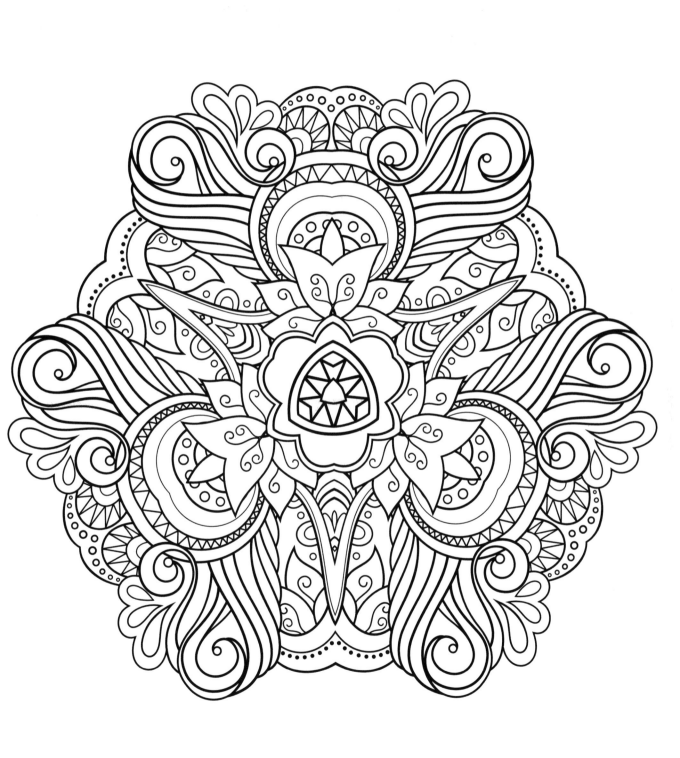

What are some names you could give this picture?

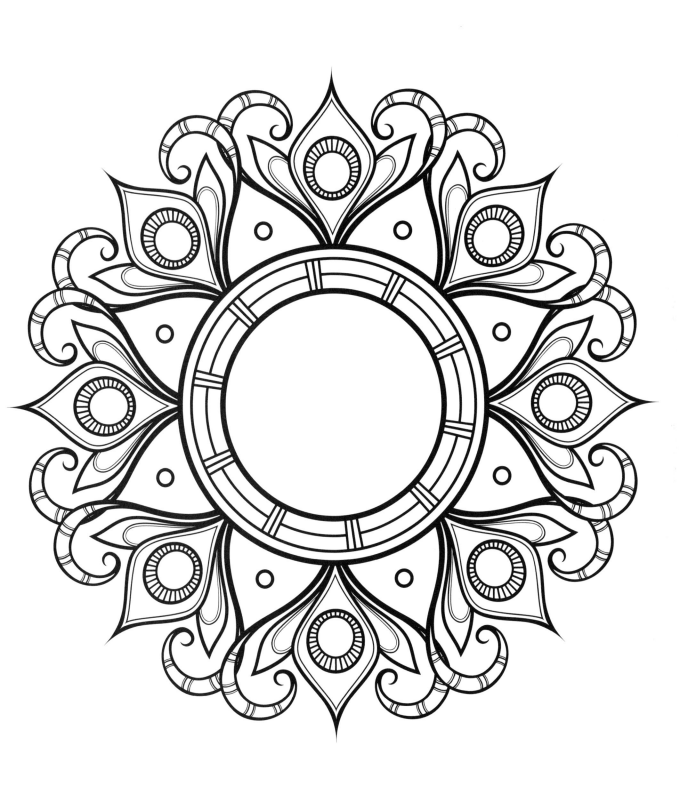

Does this picture remind you of anything in your life? Think about a time when you saw or read about this image.

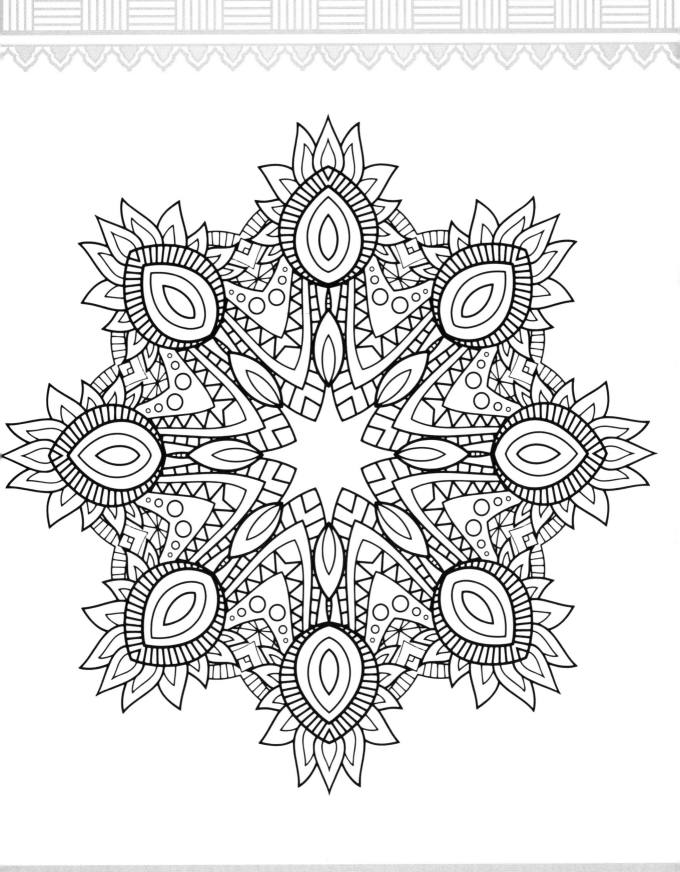

What do you have in common with this picture? Is it happy or serious? Whimsical or realistic?

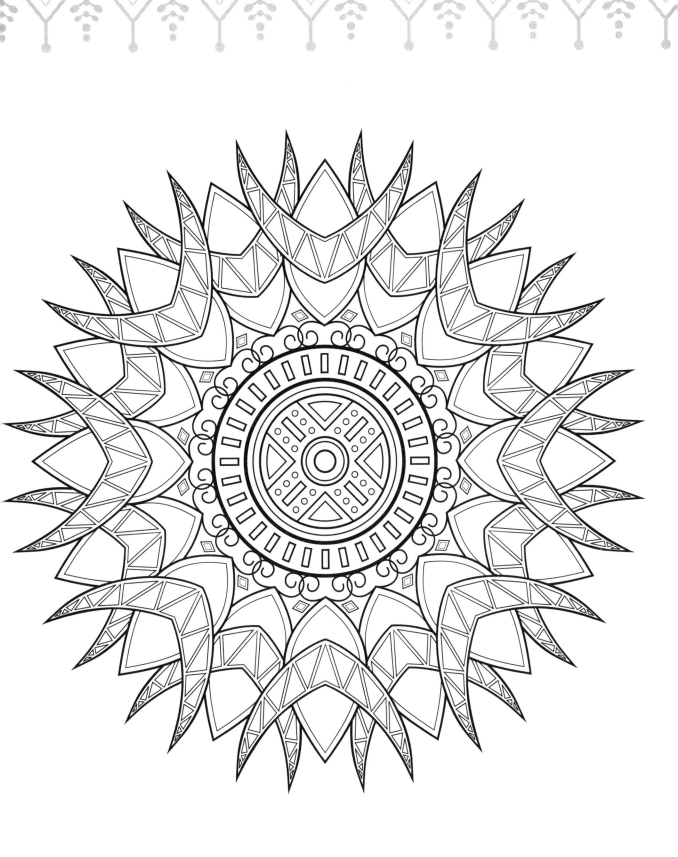

How does coloring these small spaces create a sense of importance in your life?

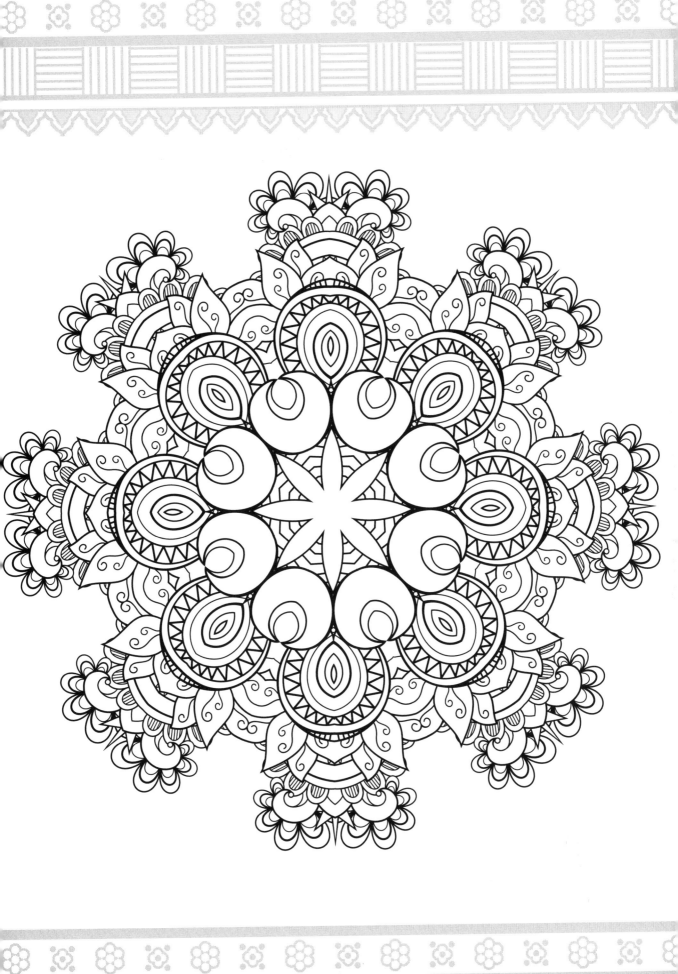

The mandala has been defined as a circle of unity. Who do you feel united with in your life? Why do you feel united with them? Is it a feeling of happiness, security, hope, inspiration, or another feeling that unity stirs up?

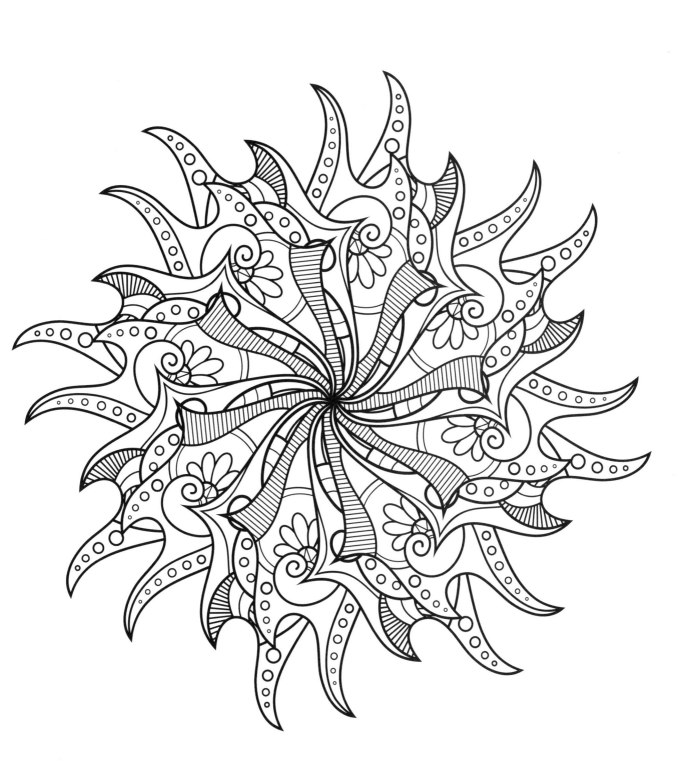

What about this picture makes you grateful? What are you grateful for?

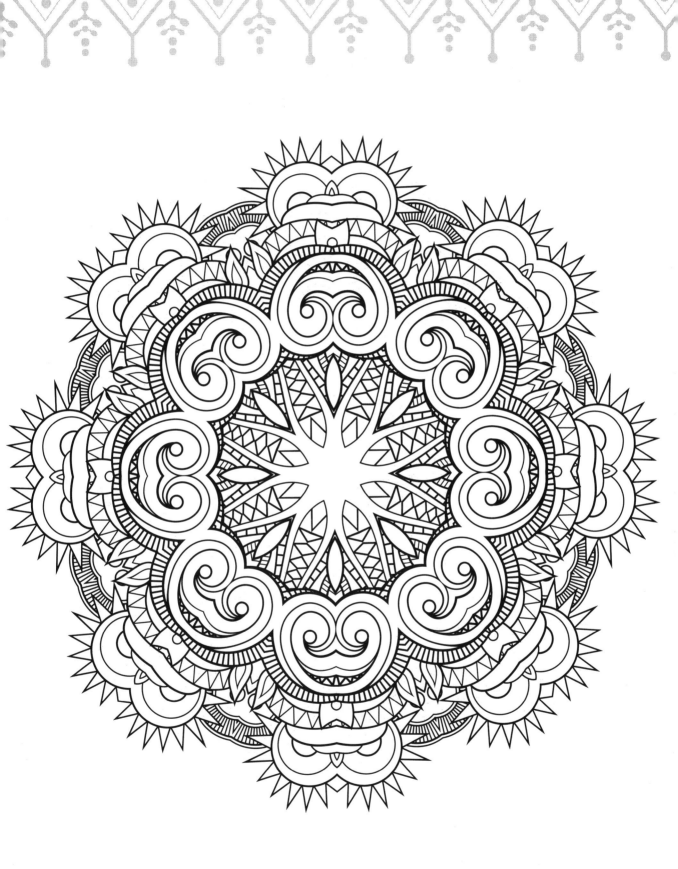

Do you remember playing childhood games in a circle? What does it feel like to remember holding hands with other children while laughing and singing in a circle? Can you think of occasions where you can be in a circle with friends and family now, and feel happy and loved?

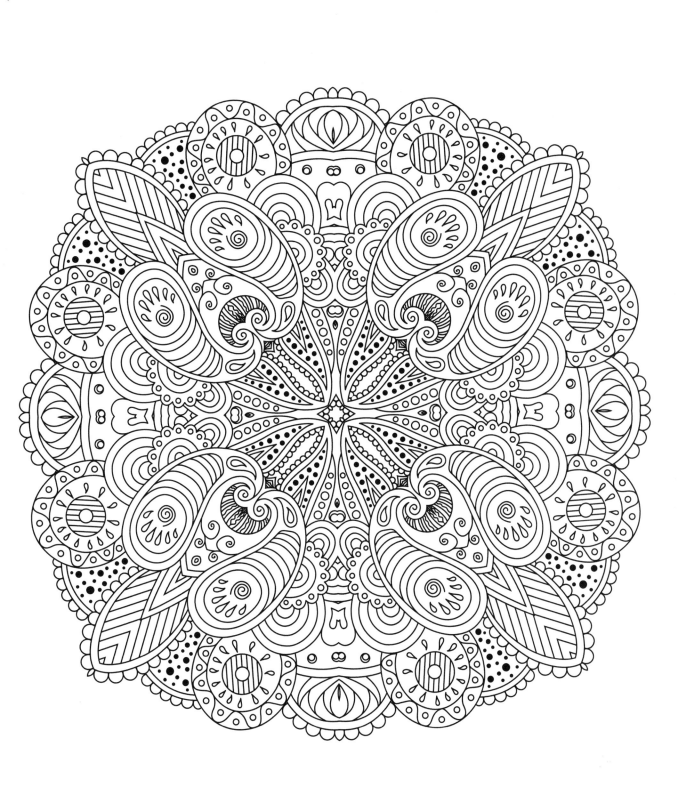

When you reflect on this picture, think about what you hope for in life. What are your hopes for today?

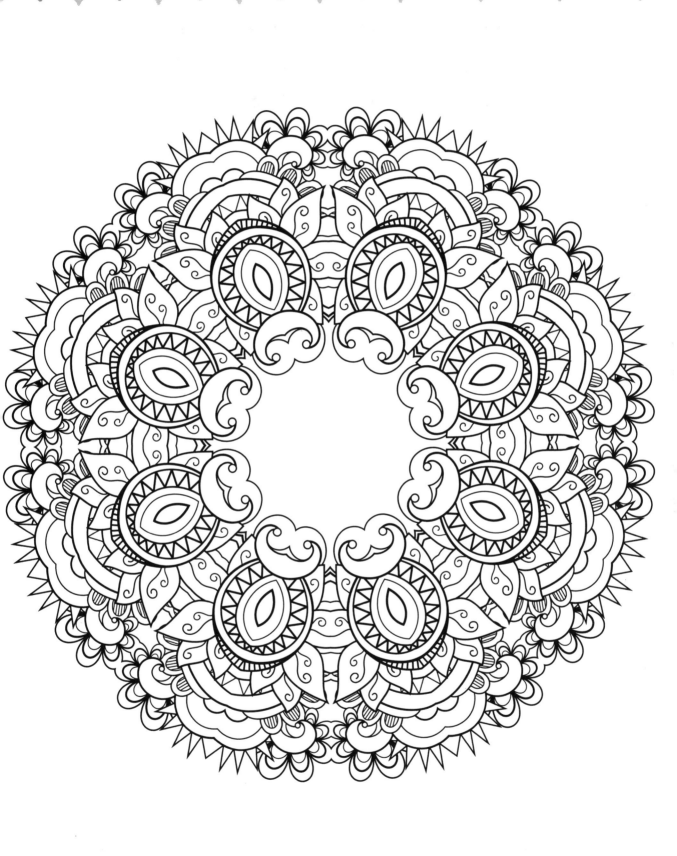

How does this picture inspire you to be your best? How do you define the word best? Can your best be different from someone else's best? Why does this matter?

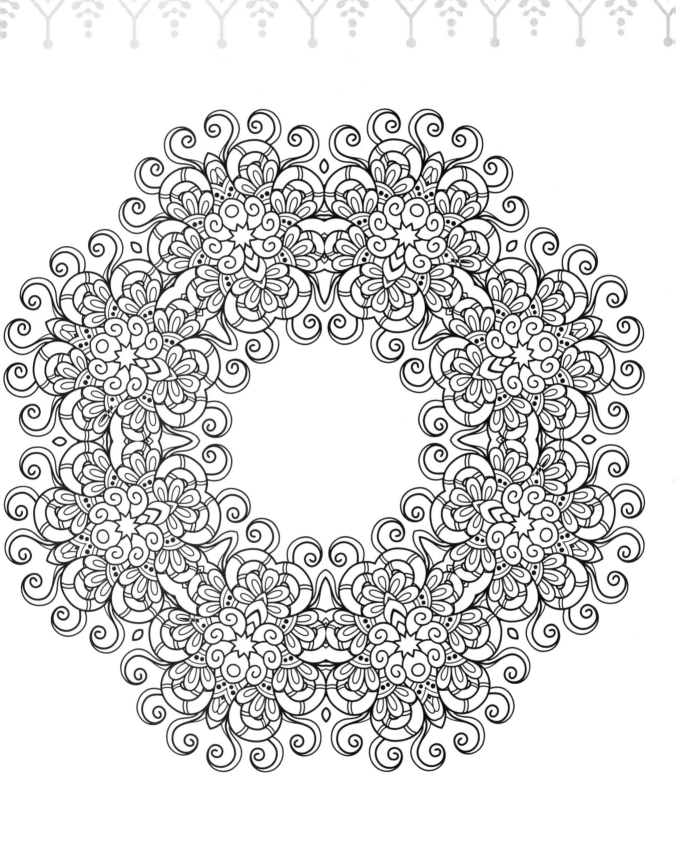

Does coloring calm you and comfort you? Describe other practices that make you feel calm.

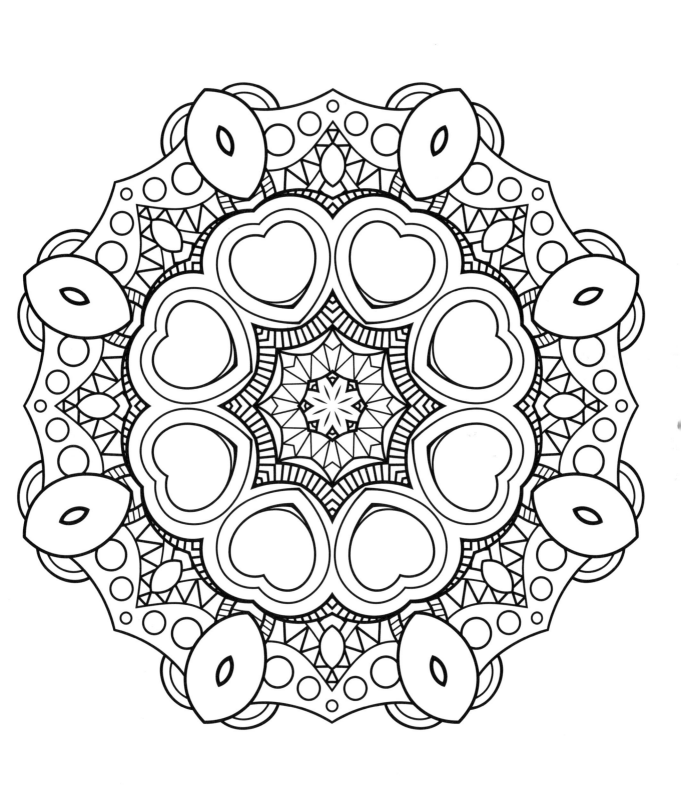

As you color these pages, do your troubles
and frustrations melt away? If or when
they return, do they seem less troubling
and more manageable? Can you get a
different perspective on them when you
take a break by coloring?

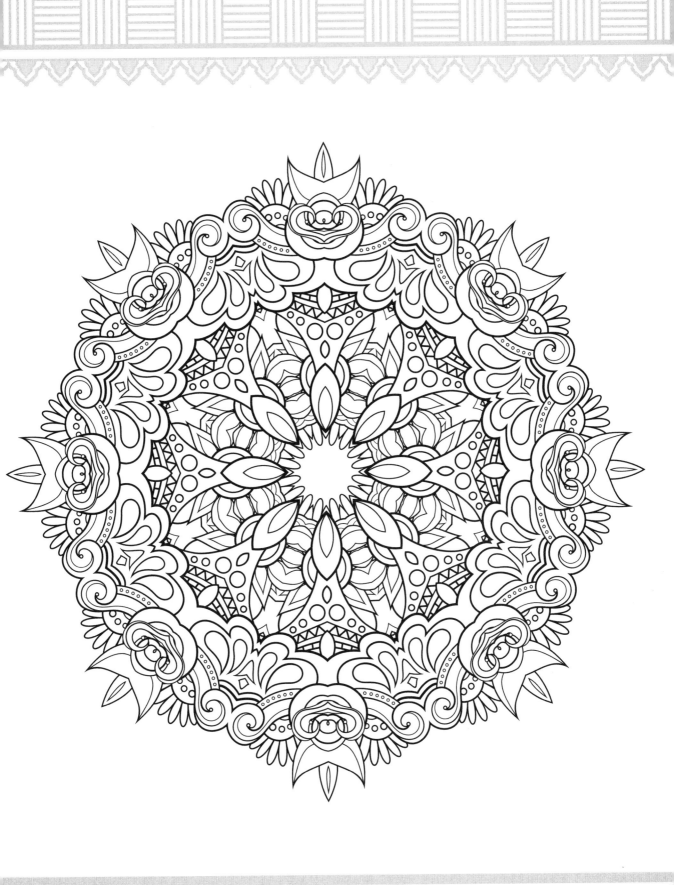

As you color, tap into your feeling of purpose. What else gives you a sense of purpose in life?

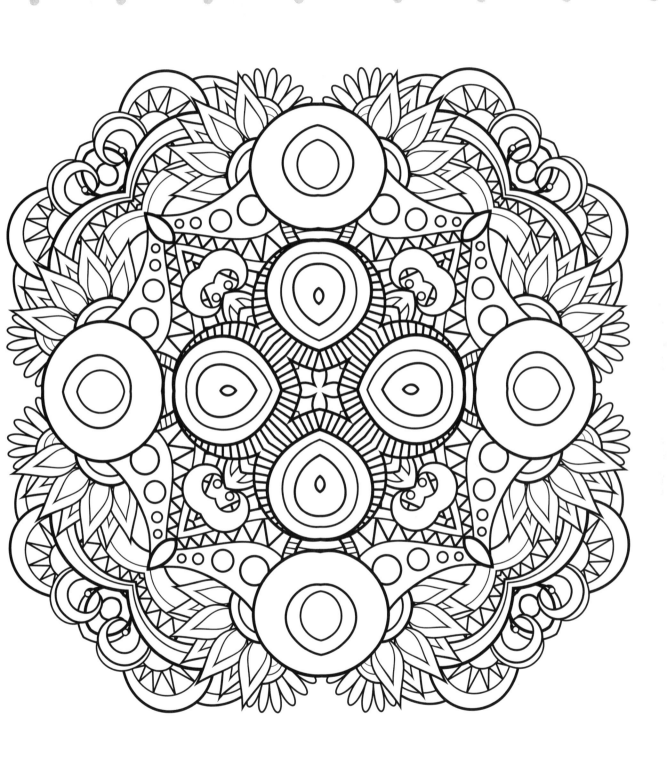

As you color, think about your desire for immediate gratification. What are the pros and cons of immediate gratification in your life? Try not to judge your thoughts! Just be aware of them.

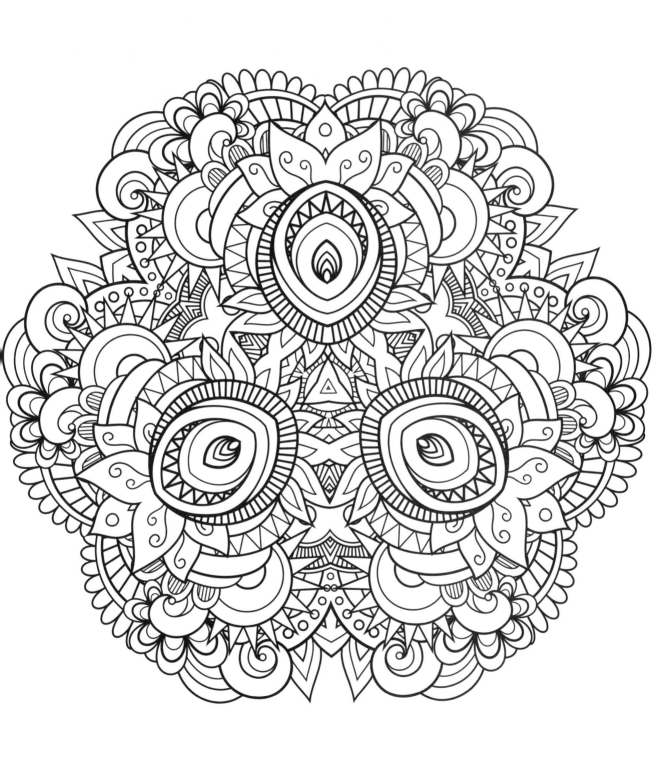

What colors do you gravitate toward in your artwork? How do different colors make you feel? Does the color red stir up different feelings in you than the color blue? Which colors make you feel calmer? Can you surround yourself with more of this color? How and where?

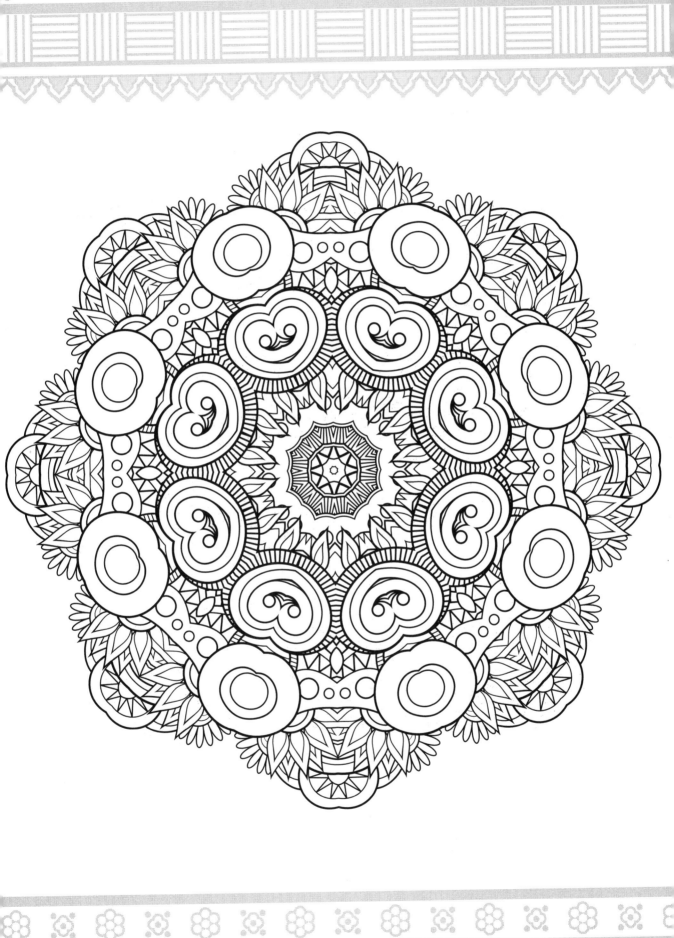

Do you find yourself coloring more when you are happy, or stressed? Bored, or nervous? How does coloring help you? How does coloring distract you? Do you consider it a good way to channel your energy?

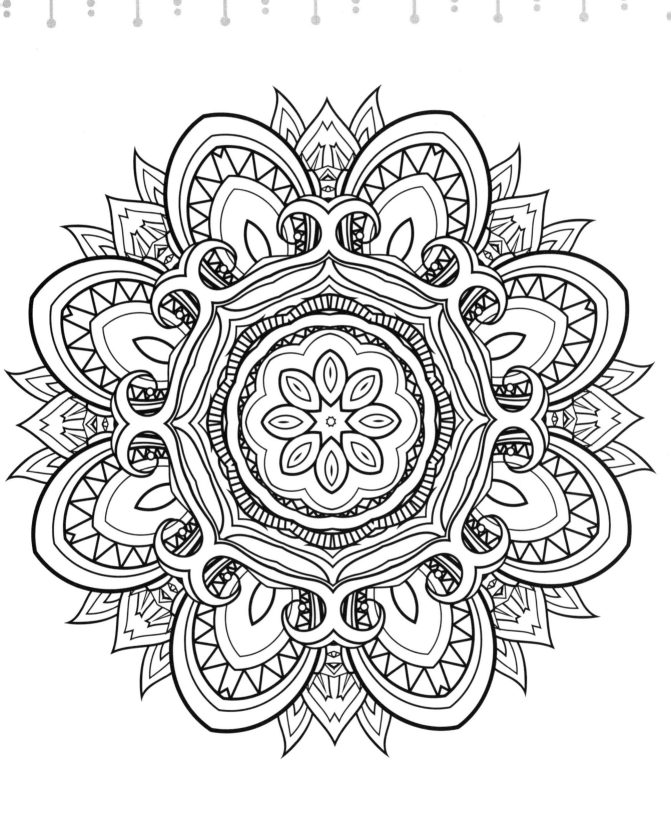

What does the expression "the circle of life" mean to you? What part of the circle are you in at this stage of your life? How do you feel about this part of the journey?

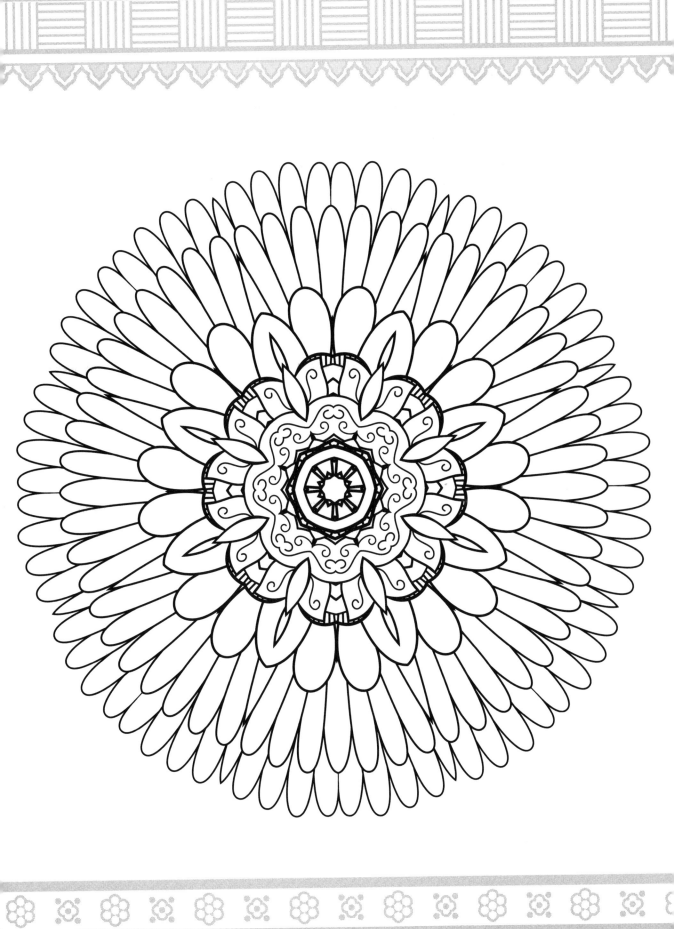

What helps you feel closer to people?
What pushes you away from people?

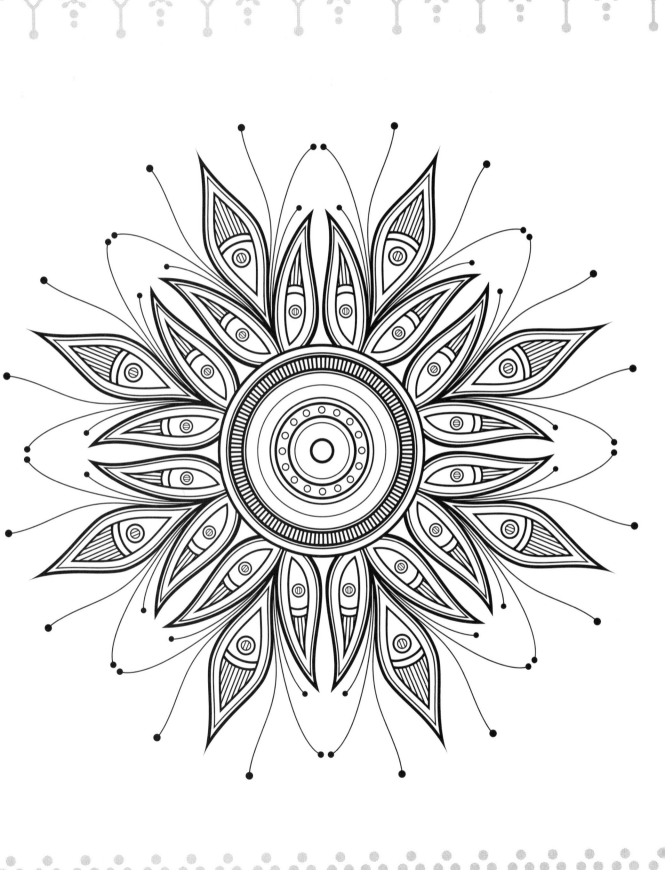

Think of some important people in your life. How can you feel connected to them while respecting each other's differences?

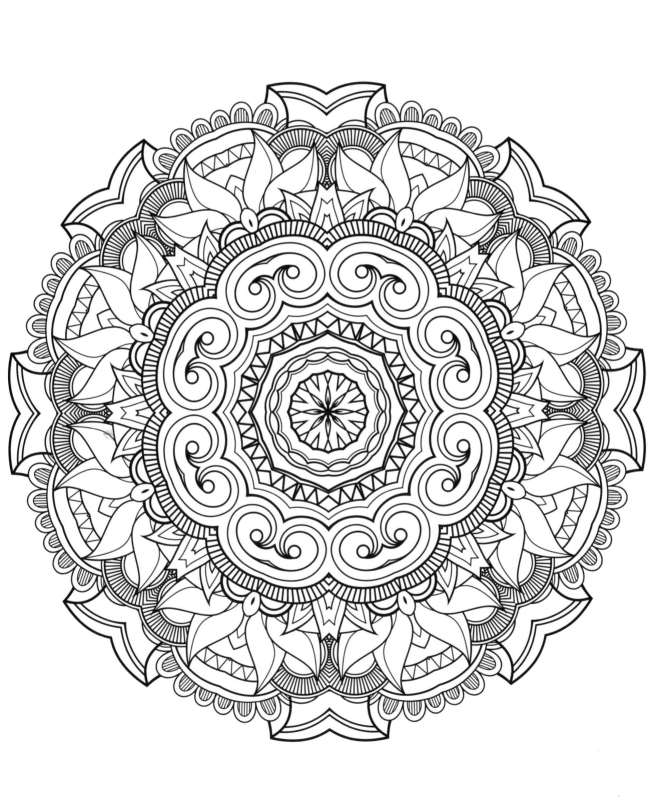

Unity has components of respect.
Who do you feel most respected by?

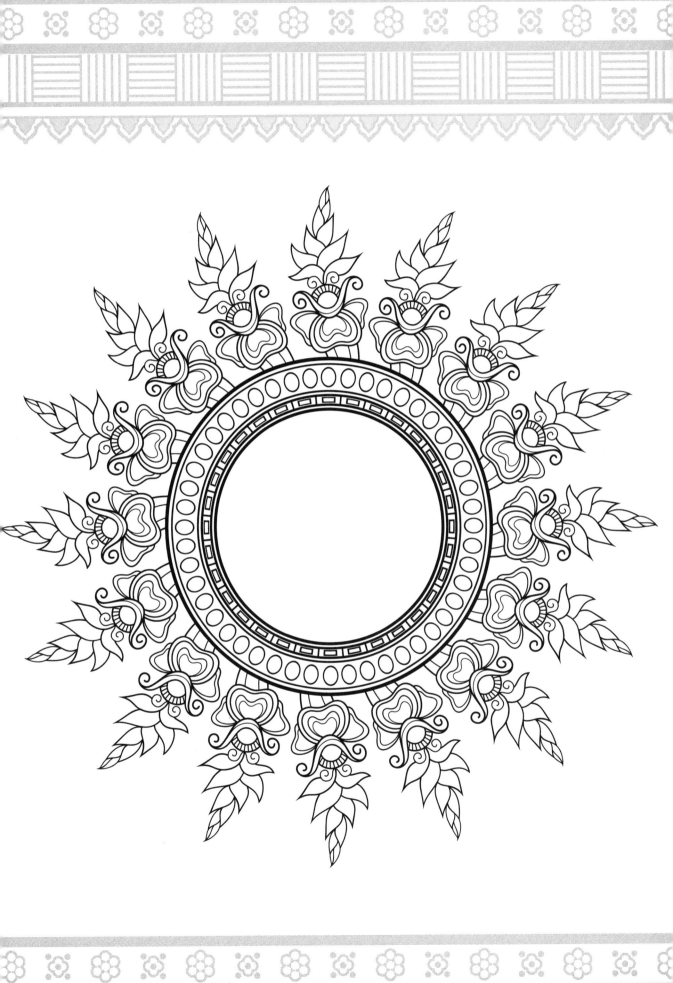

Circles are interesting because they have no end. What is unending in your life?

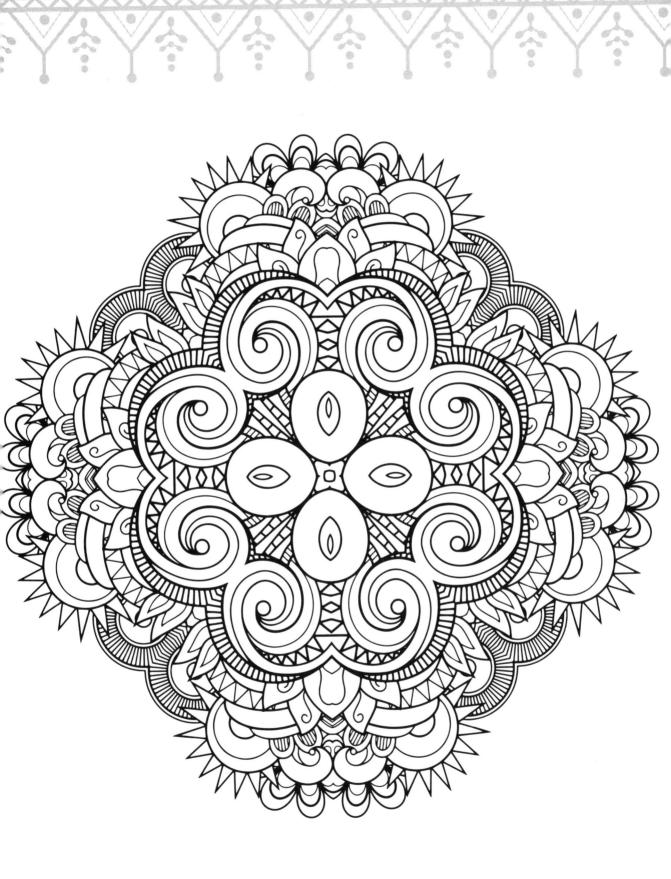

After coloring these mandalas, can you think of some symbols of unity in your home and in your life?

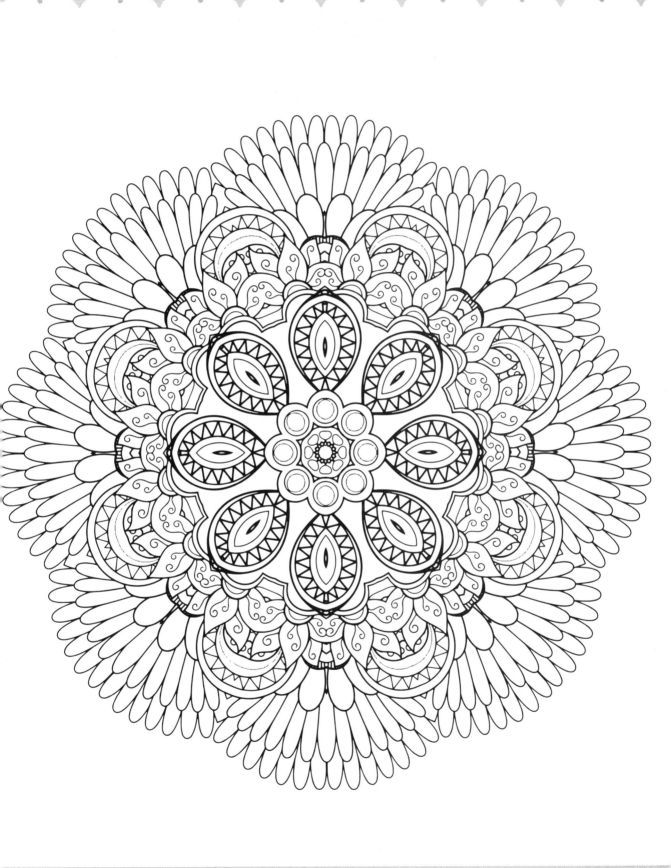

What do these mandala shapes inspire in you to believe about life and being connected to the people and places that are in your life?

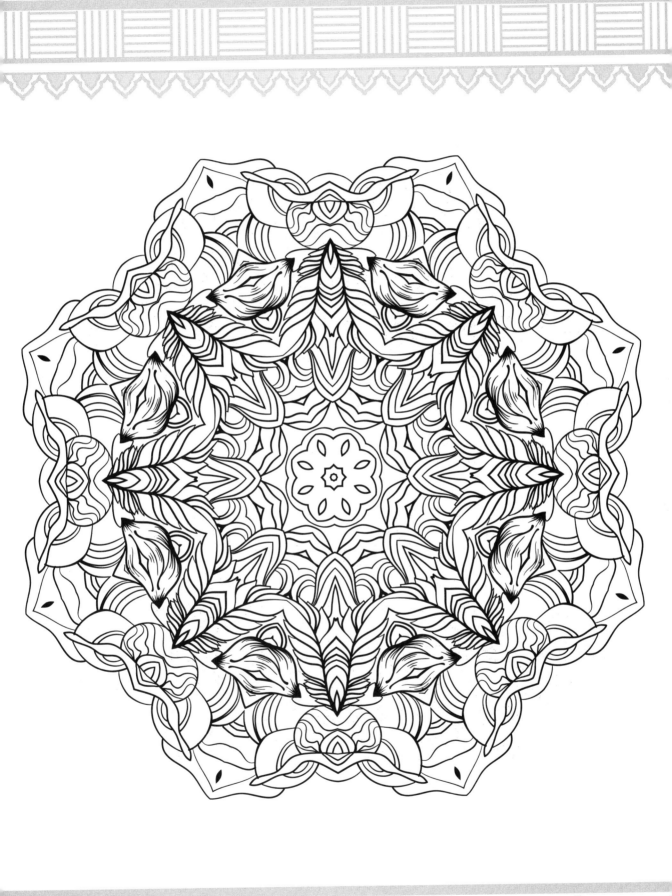

Do you like asymmetrical designs?
Do you think they add a special kind
of energy to your life, like whimsy and
playfulness? Does asymmetry ever make
you feel chaotic and out of balance? Why?

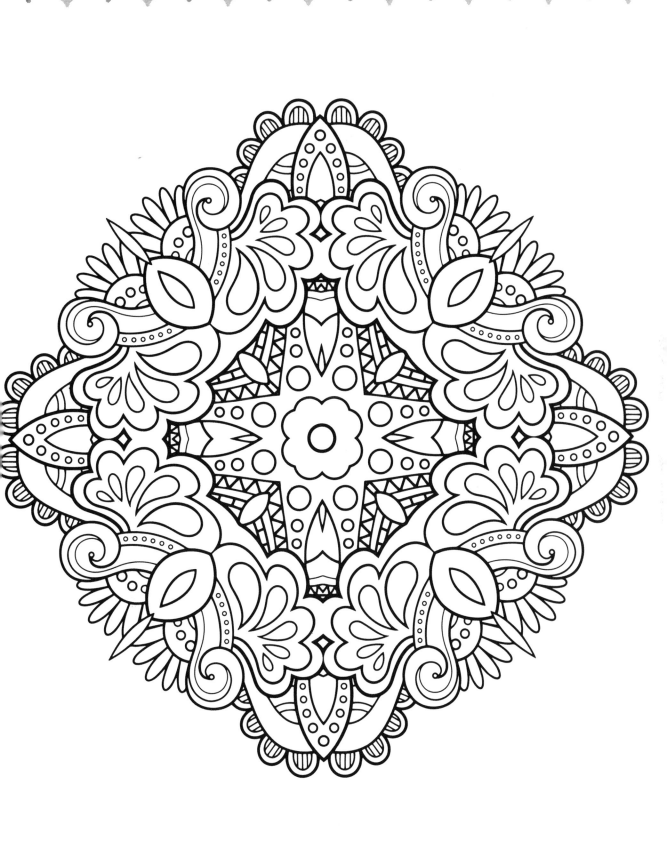

Sometimes we seek out certain types of patterns for our homes and our belongings. What do you think the patterns that you choose say about your personality?

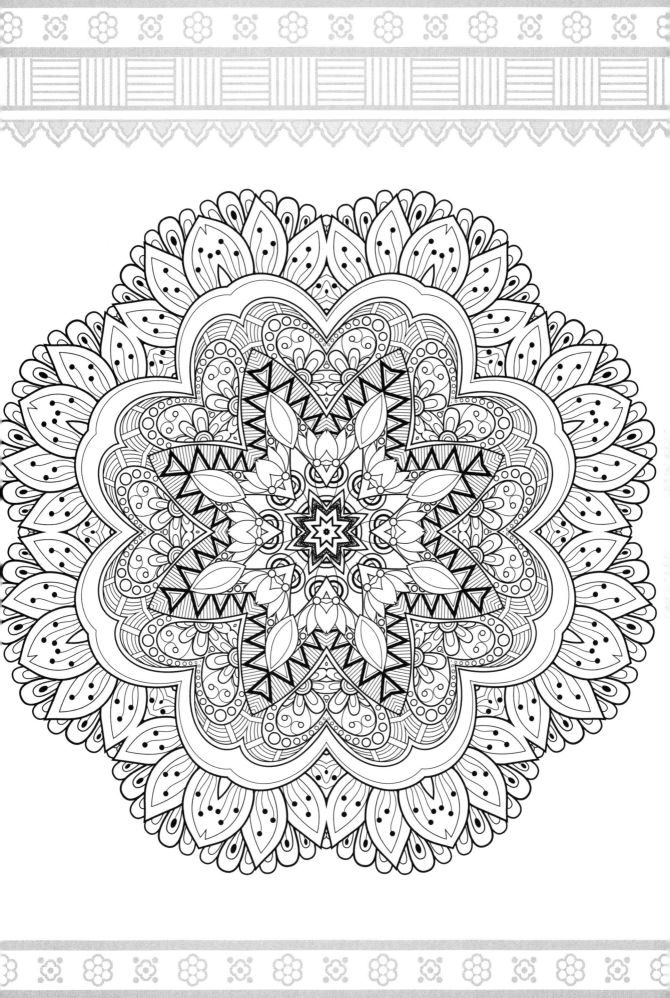

What do the mandalas that you are coloring teach you about combinations of shapes and patterns? How is it that they all combine for a beautiful look? How can everything in your life be similarly combined for a beautiful total effect?

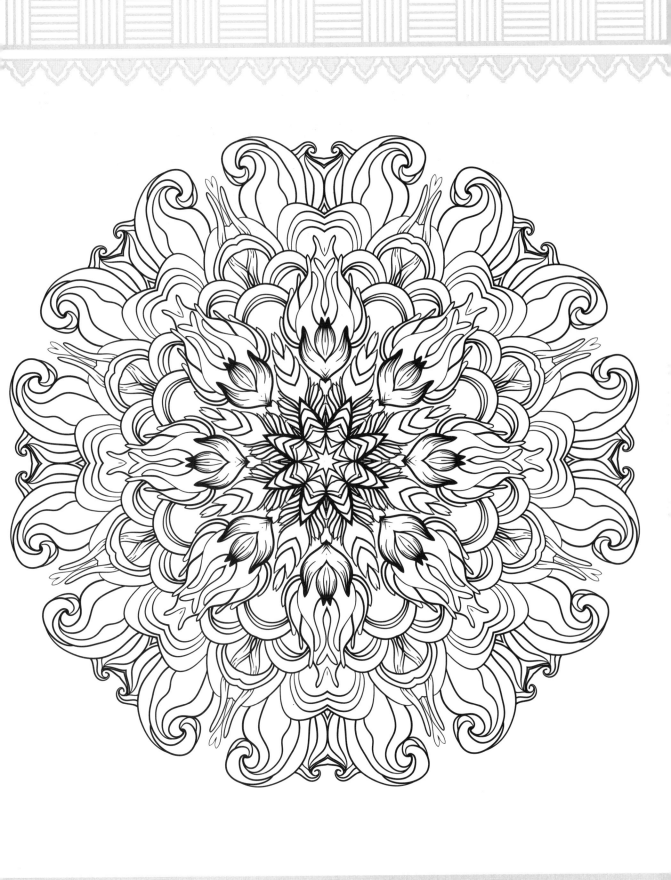

How does this picture make you feel about your life? Are you connected in any way to the image on it?

